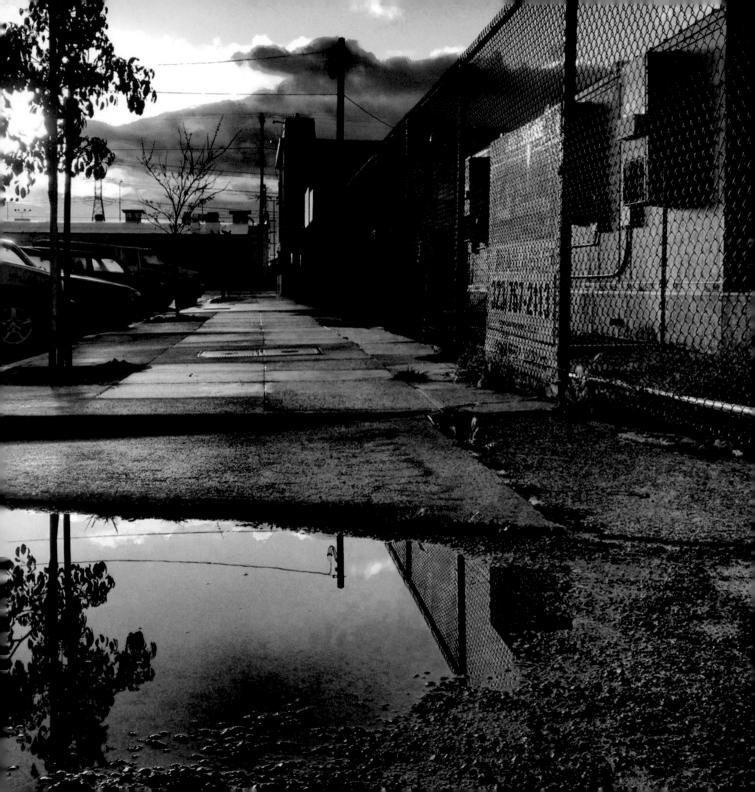

This book is a publication of
CauseConnect LLC
P.O. Box 292019
Los Angeles, CA 90029-8519
Copies may be ordered online at www.downtownmuse.com/muse-ings.

Printed in China

© Photography and text by Melissa RIchardson Banks for Downtown Muse
Art direction, cover design, and book design by Christy Addis for True Design
Published by CauseConnect, LLC

CauseConnect
www.causeconnect.net

Downtown Muse
www.downtownmuse.com

True Design
www.truedesignservices.com

ISBN 978-0-9891148-1-3

Front Cover: Yellow table and skyline in my favorite alley
Back Cover: "Wizard of Oz" view of skyline from the Cornfield
Front Page: Wet sidewalks on 3rd Street after the rain
Back Page: Sundown on my rooftop
Page 95 (top photograph): Melissa Richardson Banks aka Downtown Muse in front of
 artist Colette Miller's angel wings. © Gary Leonard

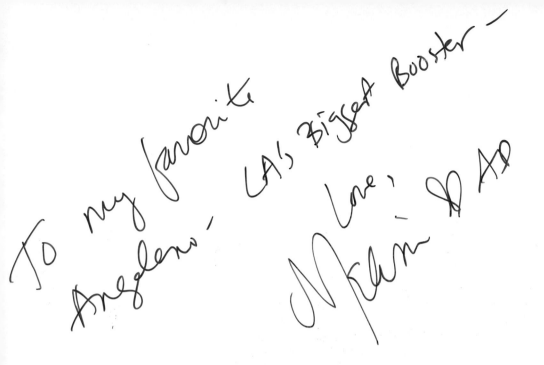

MUSE-ings
Snapshots of the Arts District
Downtown Los Angeles

by Melissa Richardson Banks

intro

I just woke up. Mind you, I don't try to wake before dawn. It just happens. I've always been an early bird – an alarm clock in my head buzzes my entire body long before the sun rises. It's not startling to me; it's simply required to activate those parts necessary to roll out of bed. Having a menagerie of dogs and cats doesn't help. I'd get nuzzled to death if I didn't move fast enough. My routine is set at a quick pace once I finally do get up -- dole out food, put on whatever I can grab, fasten leashes, and head outside with two happy mutts pulling me out the door.

Of course, getting up early has its rewards. I get to see the sun rise, discover something that was left behind or created the night before, enjoy the quiet, and greet the day in peace and solitude. It's a contrast from the escalating pace and loudness of the rest of my day ... my morning and evening walks are my meditation – time slows to a crawl, at least for awhile, and I see more of my surroundings.

For me, my snapshots illustrate what seems to be my long good-bye to a lifestyle and a place where I've lived for quite some time ... Downtown has been my muse for 20 years and the Arts District is my photographic inspiration. My saturated colorful memories are what I see in my brain every time I look around. I wish I could paint, but I can't, so when I see something that matters to me, I take a photo. My motivation is that I don't want to forget a thing, and since rapid changes are in the making, I am inspired to capture what I can so that I remember long after my inevitable departure. It's true that what I love now may not always be here, and hopefully, I'll find more to love ... in the meantime, I want to treasure what is now.

Over time, I've come to realize that my waking up is more than literal – it's figurative, even more evident to me during the process of reviewing thousands of photographs for this book. Each selection herein was taken at a pivotal point in my life over the past few years. This has been a time of reflection and transition – in my life and in my gentrifying urban neighborhood. Somehow, it seems that my longing has preceded my leaving - not just this place, but where I am overall ... I am here, but I am gone.

Melissa Richardson Banks
Los Angeles, CA
December 2013

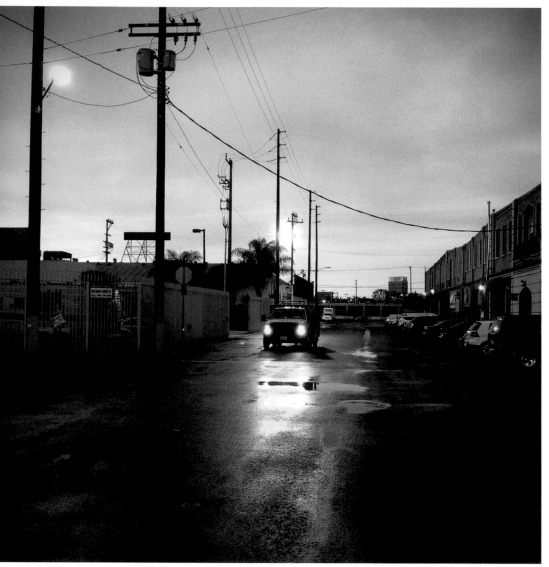

Dump truck on 5th Street near
Hewitt Street

Sunset after the rain on 3rd Street

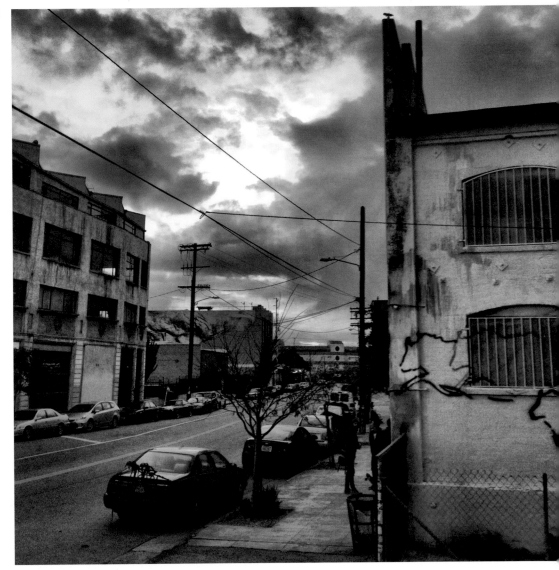

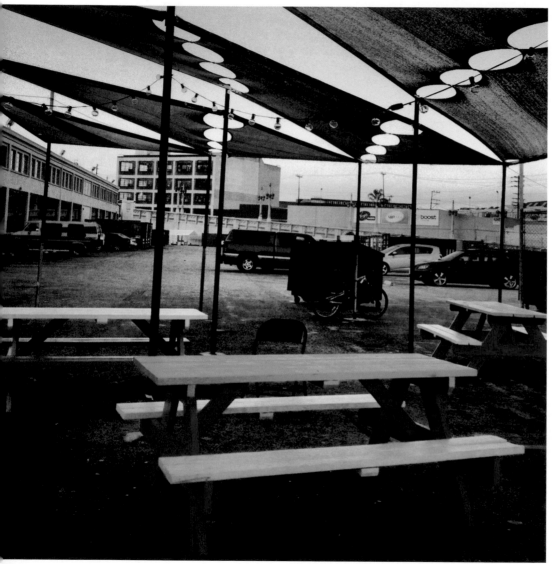

Picnic tables at SCI-Arc

Painted doorway on 2nd
Street near Garey Street

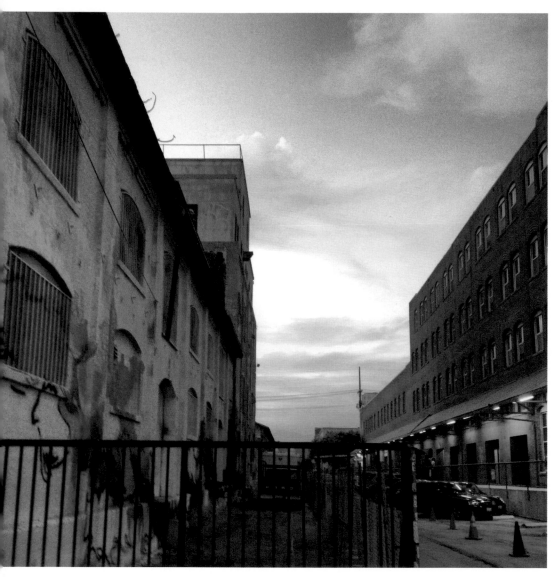

District Millworks alleyway near
923 E. 3rd St. loft building

Striped turquoise alley with
downtown skyline on fire

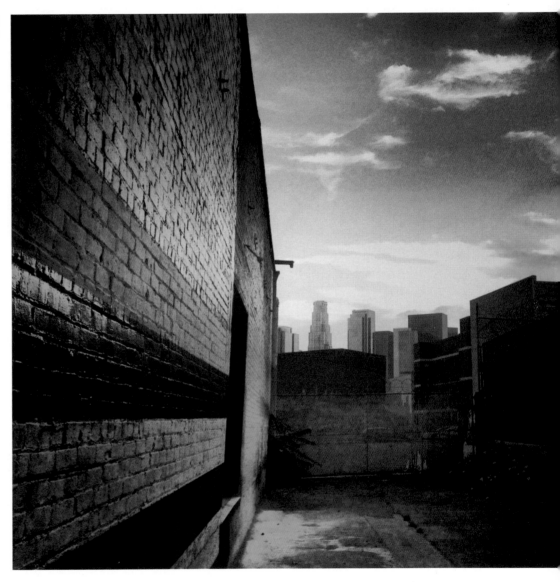

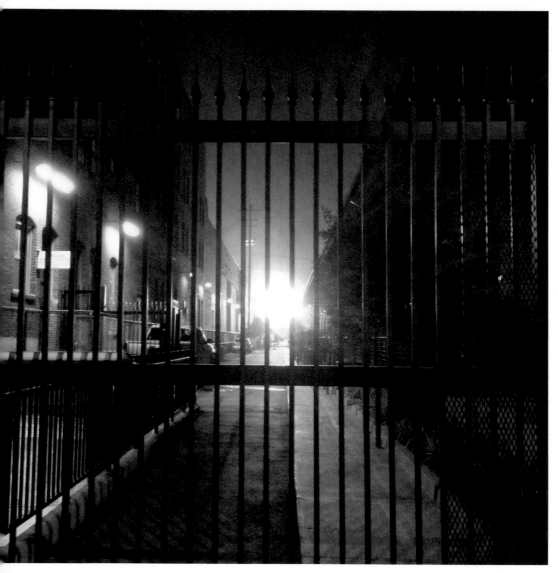

Gate in Vignes alley

Reflections in the mirror

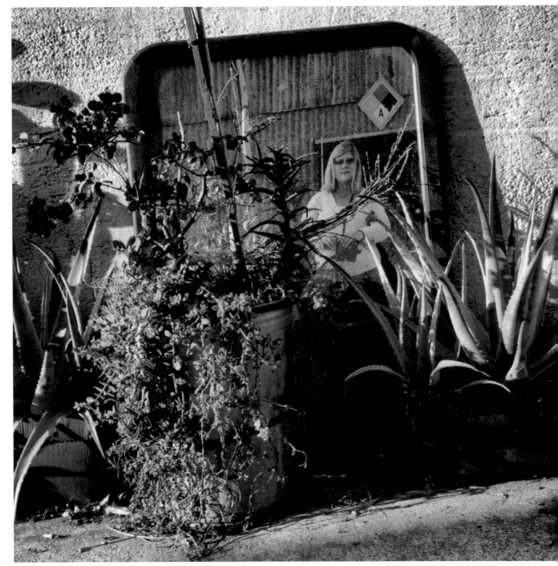

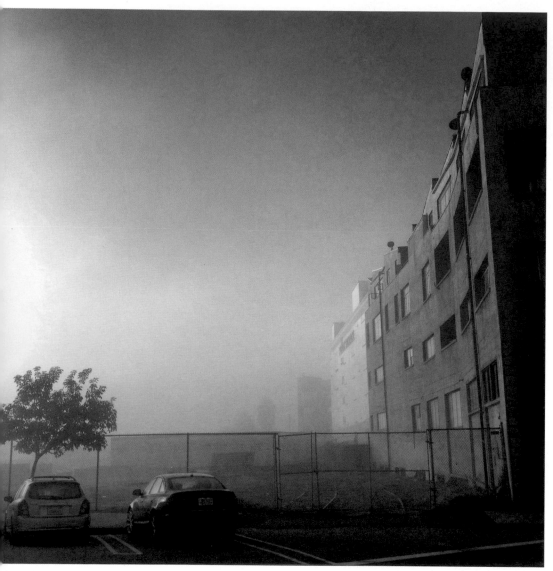

Haze over dirt lot near 912
Complex loft building

Railroad tracks as seen from
the 1st Street Bridge

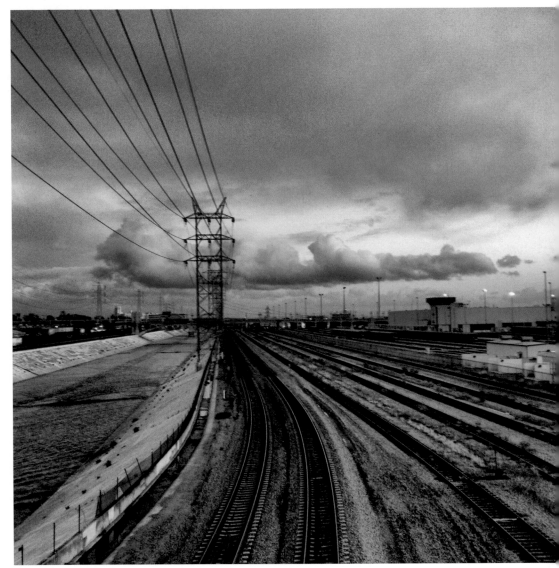

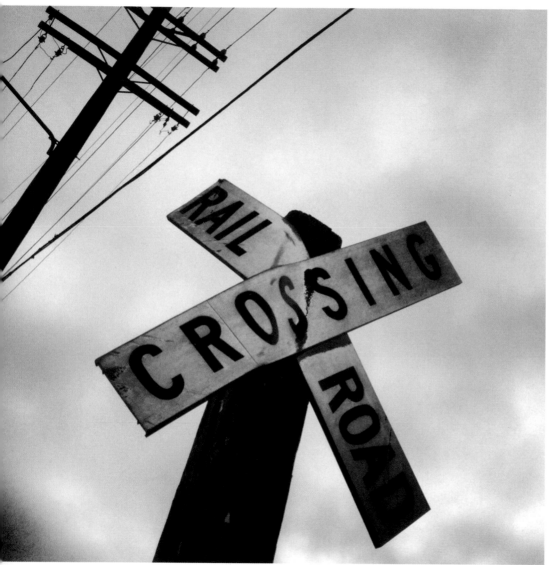

Railroad crossing sign
on Merrick Street

Downtown skyline through
the fence on Vignes Street

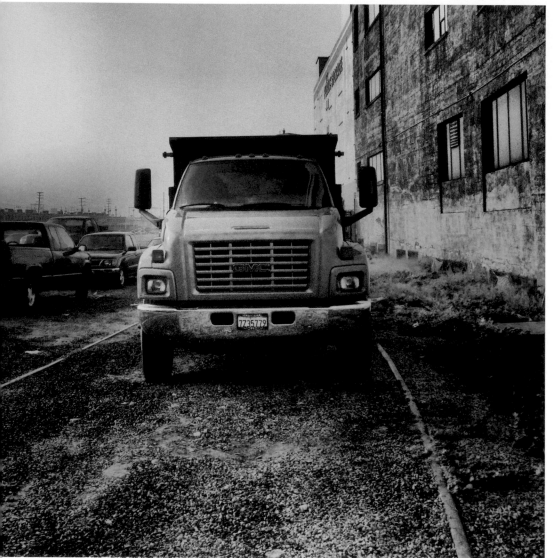

Dump truck in dirt lot
near SCI-Arc

Blooms and funny face with
serpentine wire on Rose Street

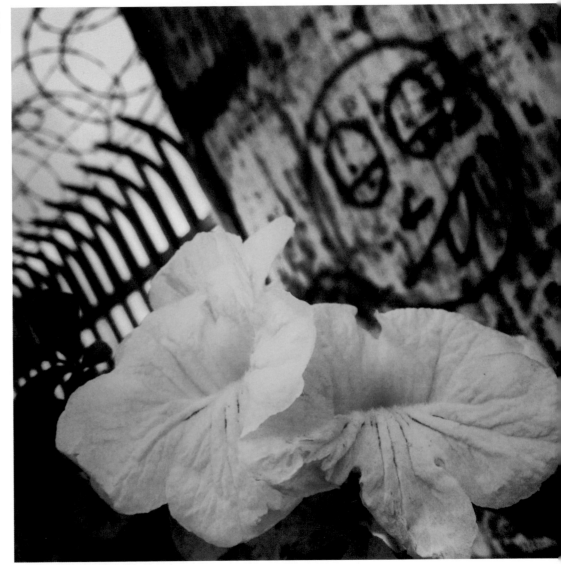

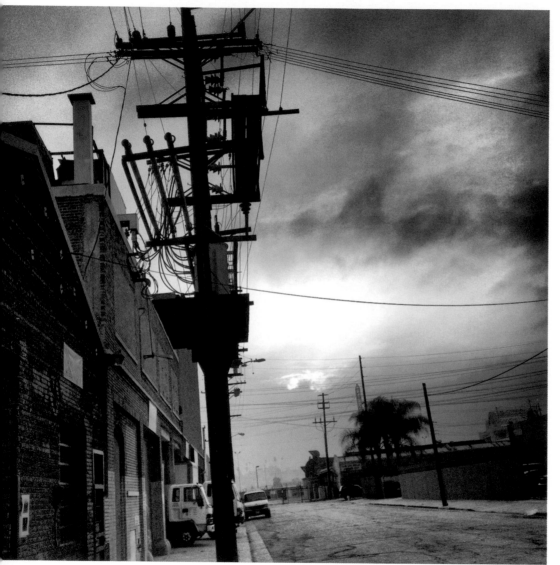

Morning sun bursts through the clouds on Palmetto Street

Vatche "sunstruck" on
2nd Street at dawn

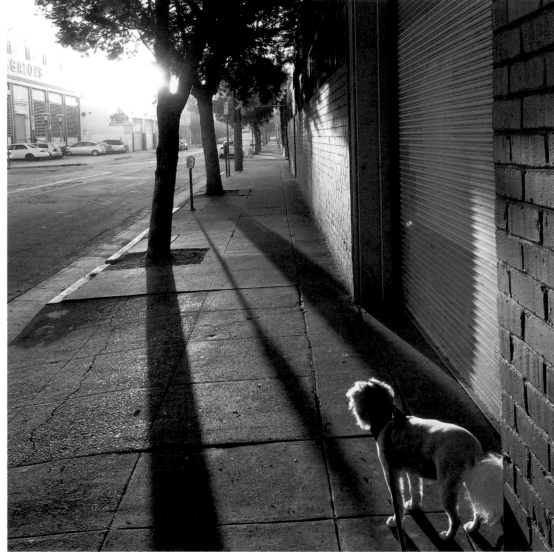

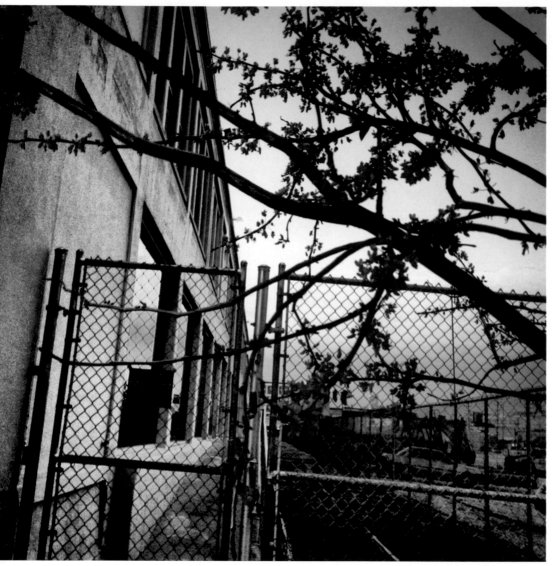

Sunrise blooms near SCI-Arc

Looking south down the
east side of 923 E. 3rd
Street loft building

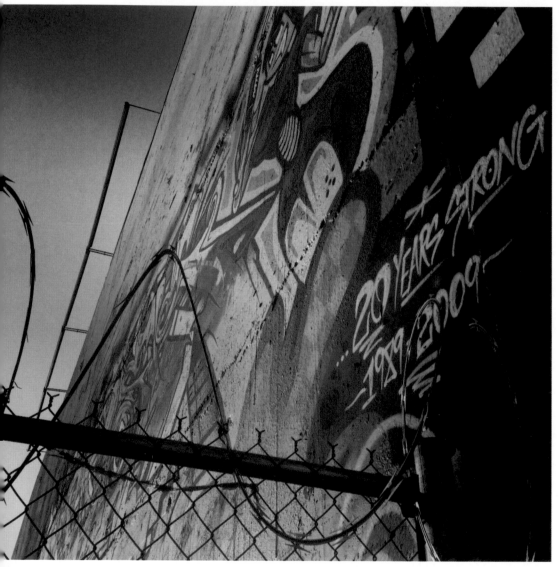

"20 Years Strong" ... detail from mural on Megatoys

Homeless man pushing cart
on 3rd Street at night

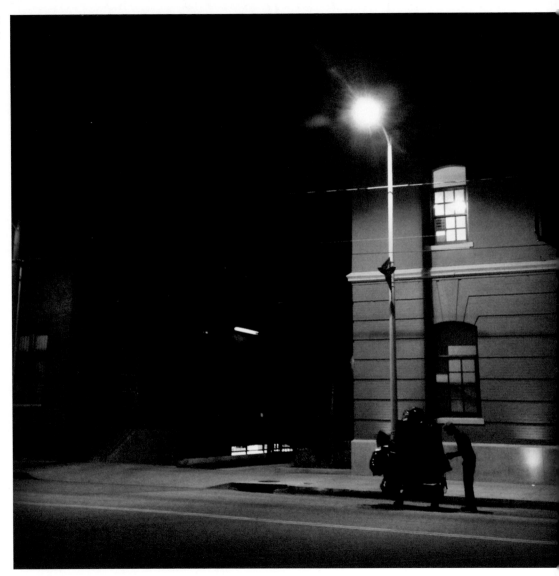

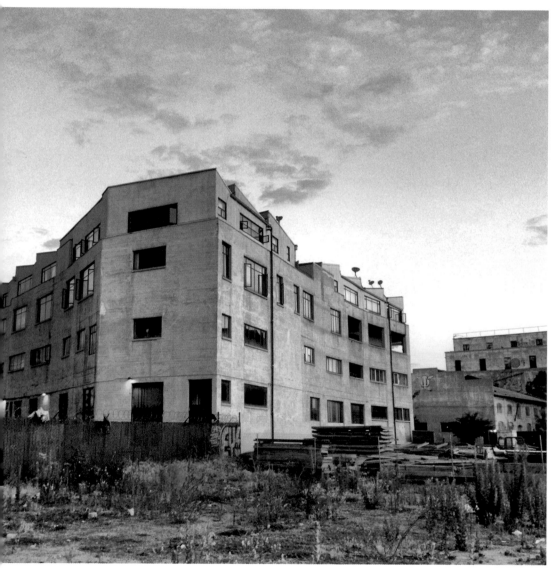

Curved sides of 912 Complex
loft building

Yellow taxi under the 4th Street
Bridge on Santa Fe Avenue

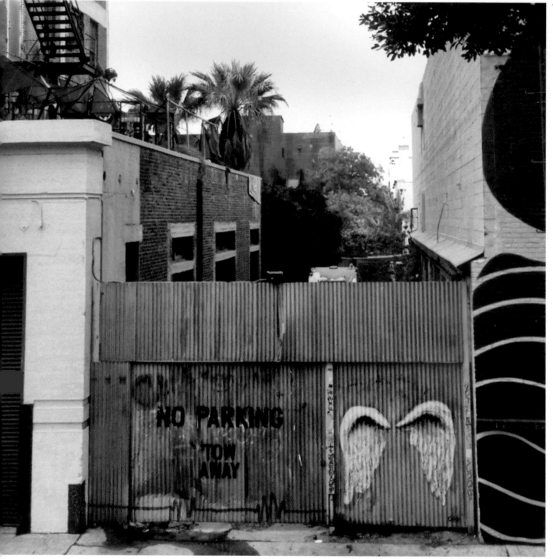

"Wings" art by Colette Miller
on Hewitt Street gate

Camping near RISK mural
on 4th Place

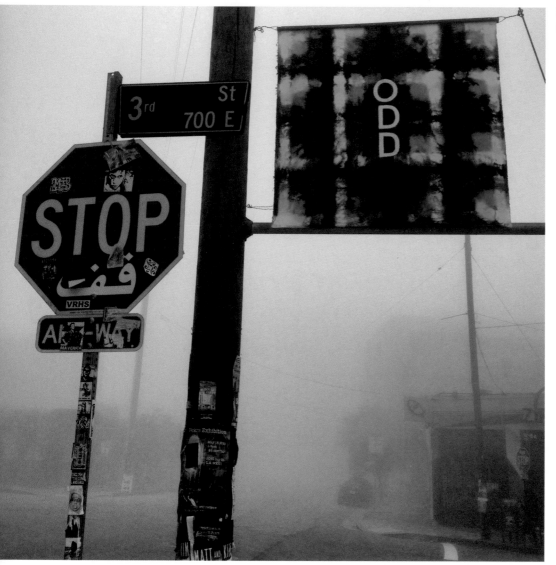

Stop sign with ODD banner and odd fog at 3rd & Traction

Urban expression of suburban
complaint: "Get Off My Lawn"

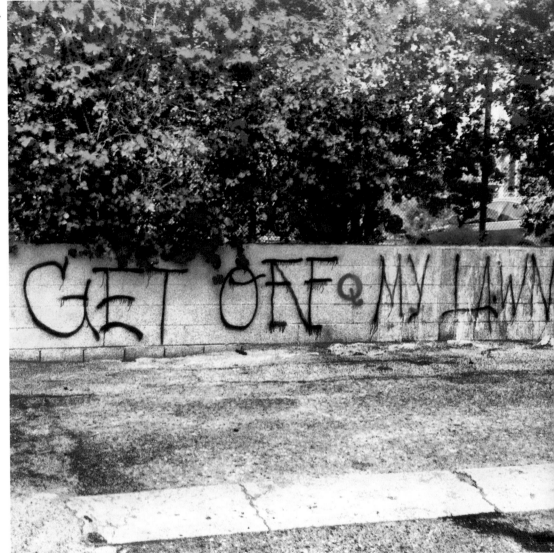

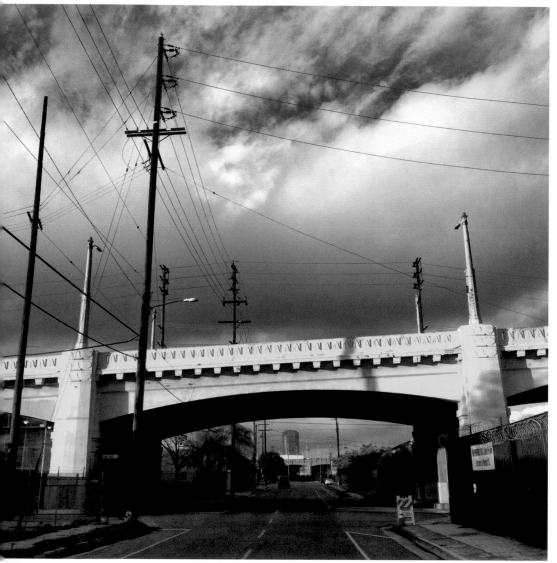

Golden 6th Street Bridge

Arts District diamond sign in vines

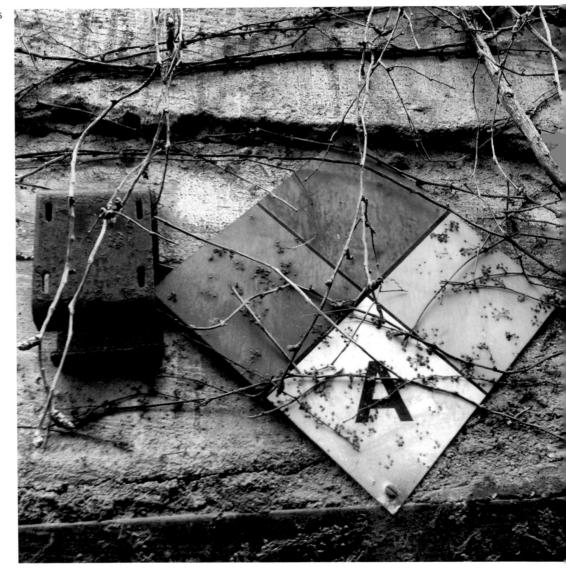

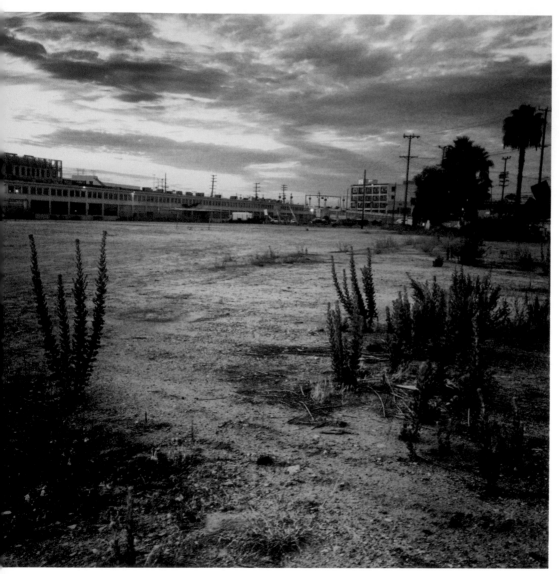

Arts District desert on 3rd Street

Red broom at Megatoys

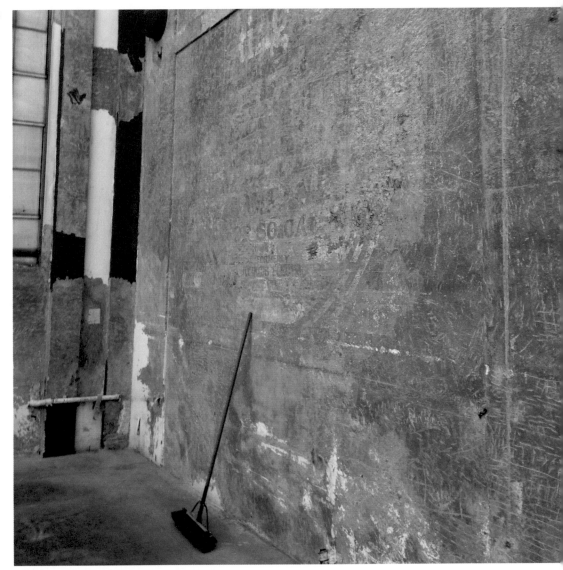

Pink trumpet trees and sunrise
on 3rd Street

Pre-dawn golden lights
with lavender glow in
alley near 2nd Street

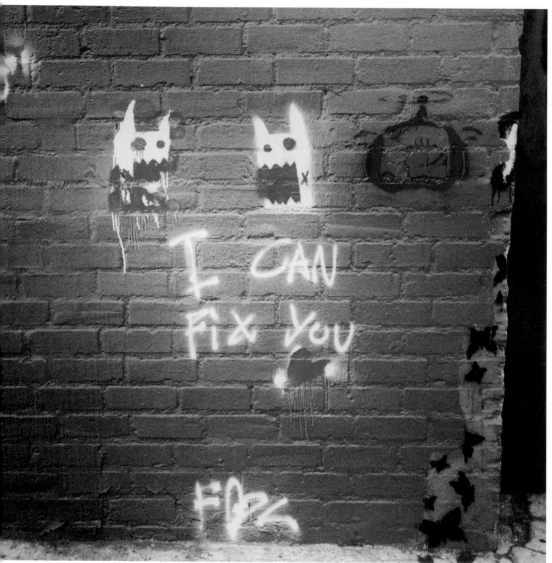

"I Can Fix You" tag near
Würstkuche on Traction Avenue

Bridget Vagedes lights her
loft on Hewitt Street

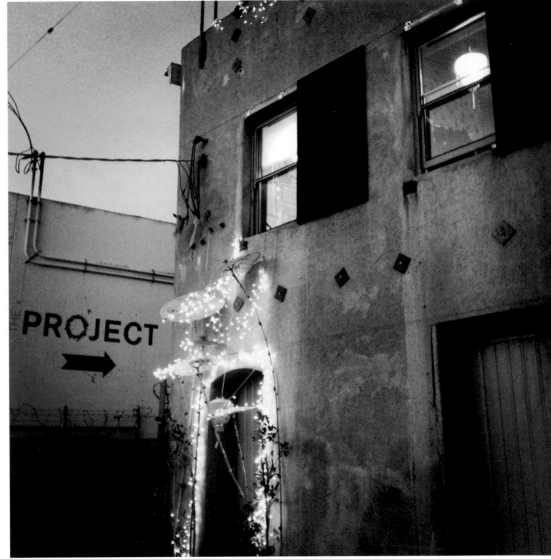

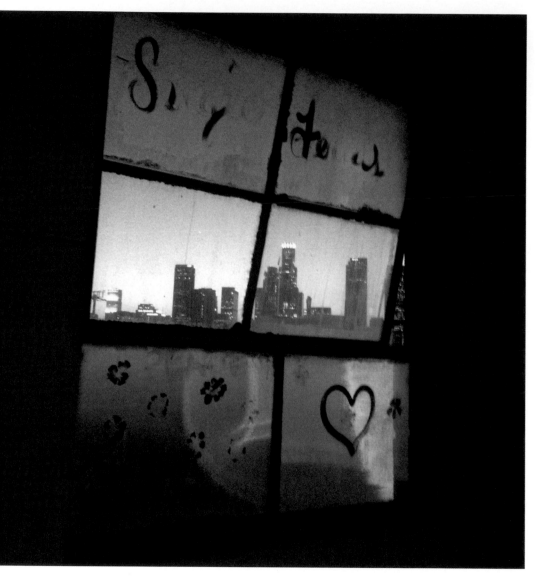

Downtown skyline seen
through window of artist
Curtis Gutierrez's
loft on Colyton Street

Curve of the 4th Street Bridge
on Santa Fe Avenue

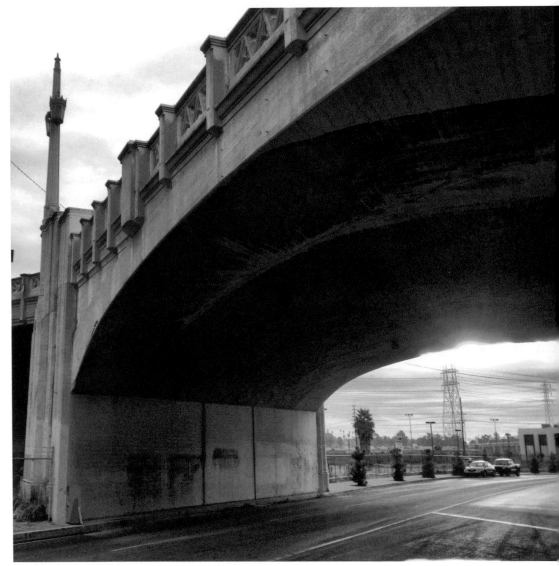

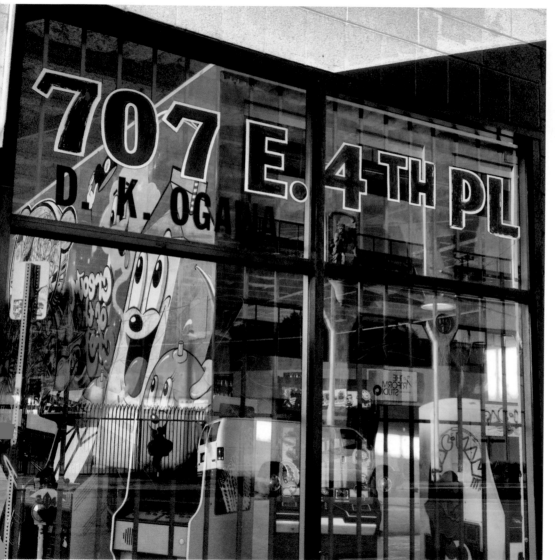

Mural reflections in window of 707 E. 4th Place during construction of EightyTwo arcade bar

10mph sign on Traction Avenue
with yellow trumpet trees in bloom

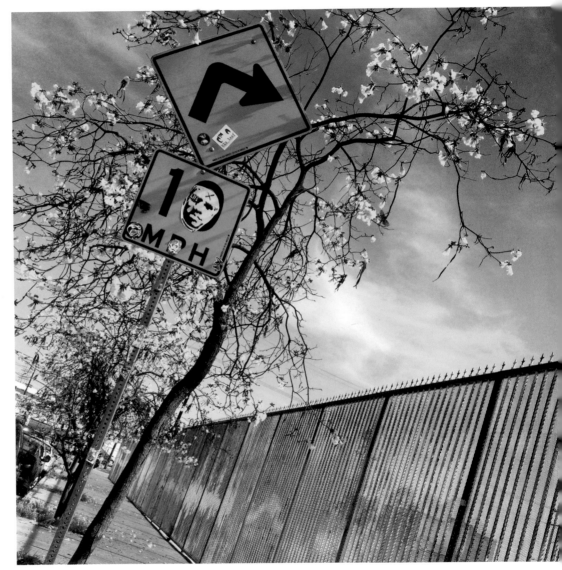

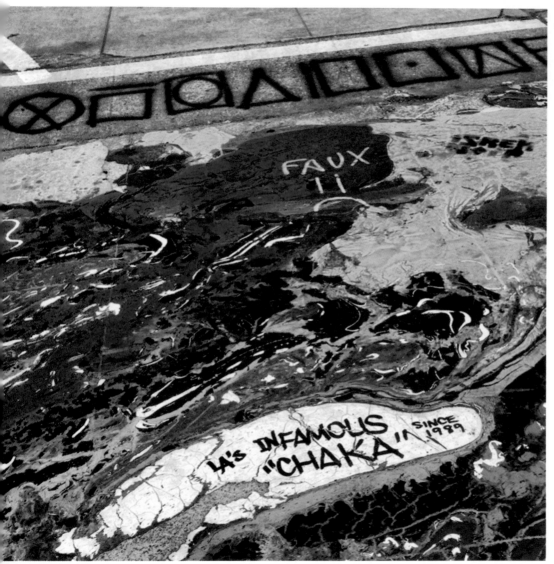

Paint on sidewalk with
"CHAKA tag

Port-a-potties on Santa Fe
Avenue at dawn

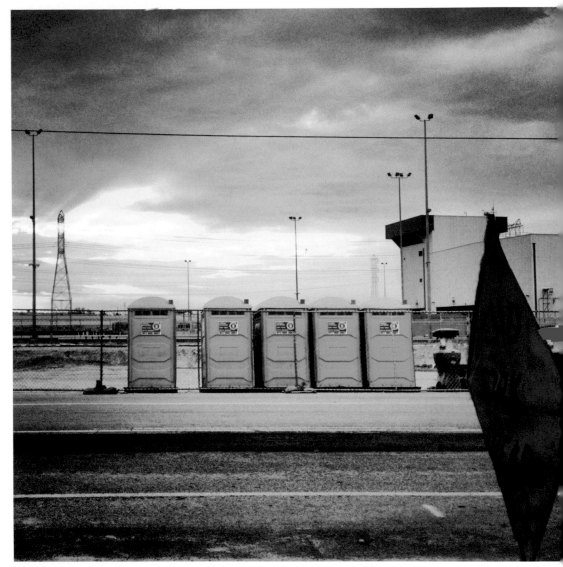

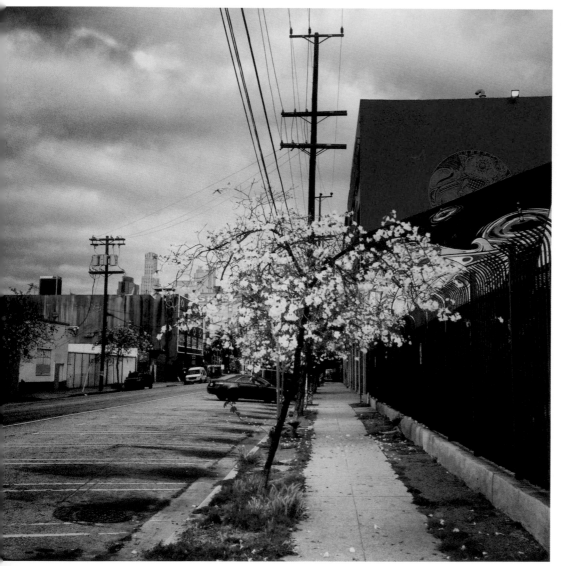

Red, yellow and blue on
Traction Avenue

46

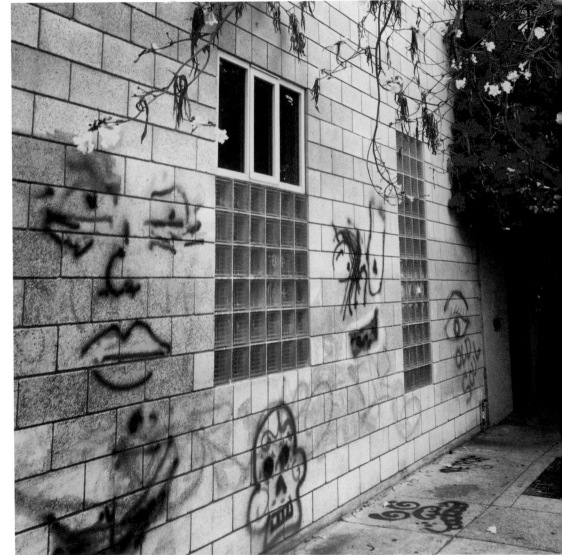

Graffiti on Traction Avenue

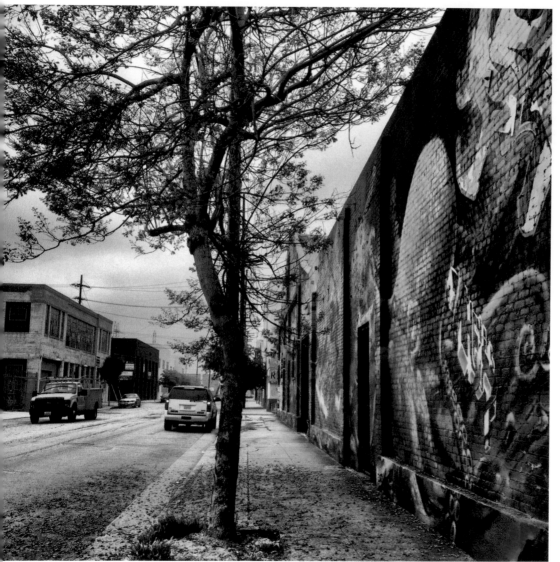

Purple tree and street art on
2nd Street

Bougainvillea and street art in
Crazy Gideon's parking lot near
Angeles Desk Co. building

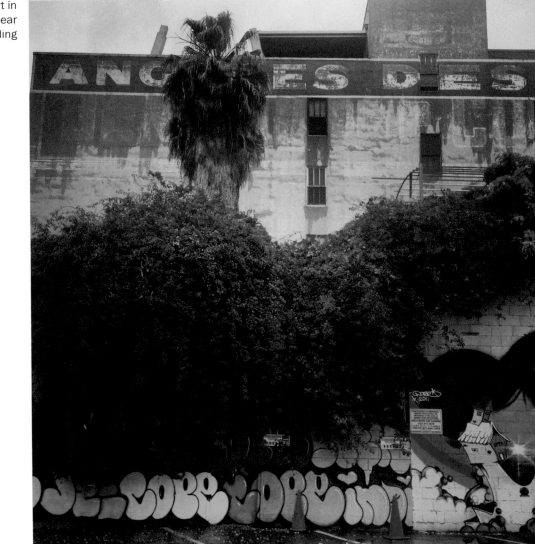

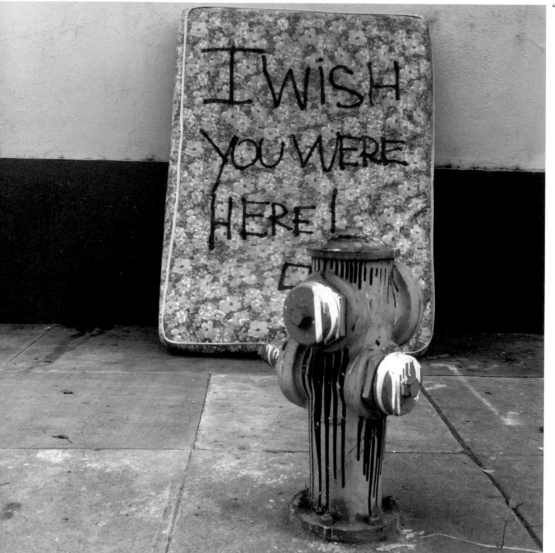

"I Wish You Were Here"
 street message

50

Street art reflection on window
of Angeles Desk Co. building

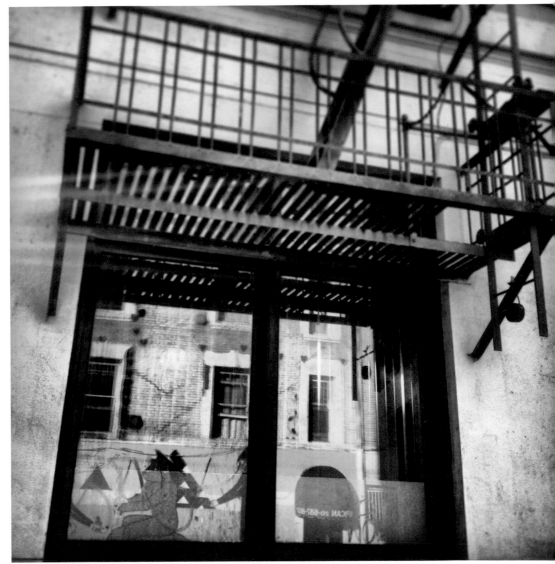

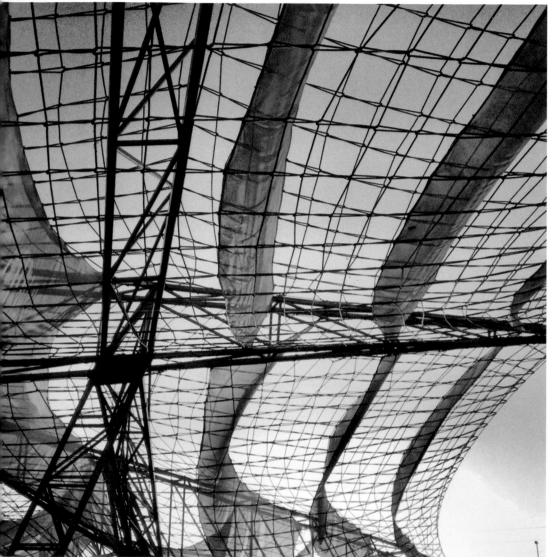

"Disney Hall East"...SCI-Arc
graduation pavilion at sunrise

7th Street and Santa Fe Avenue

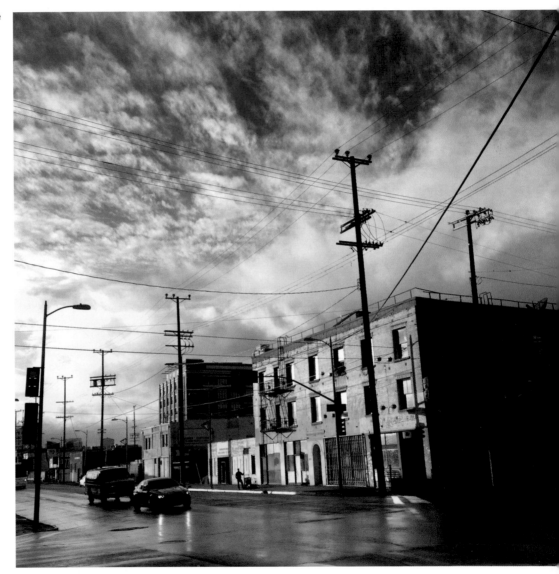

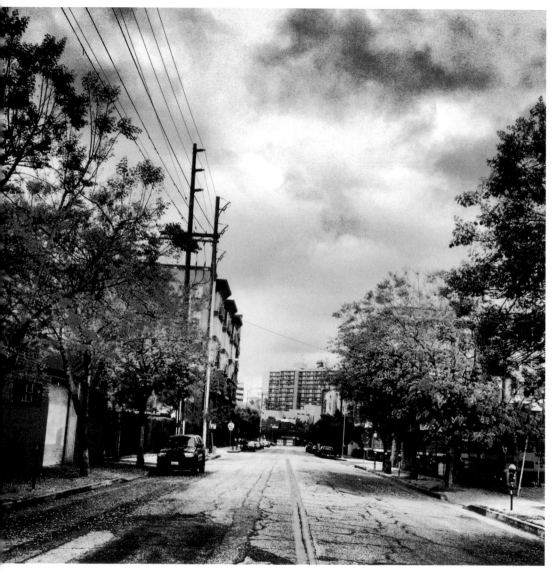

2nd Street turns lavender with
jacaranda blooms

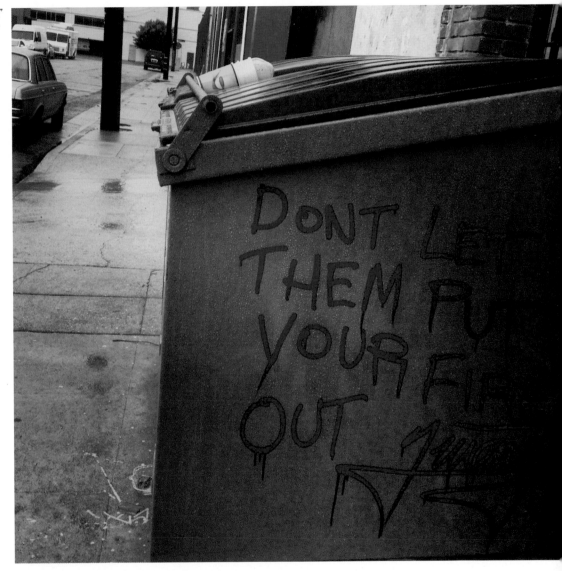

"Don't let them put your fire out"
tag on trash bin by @2wenty

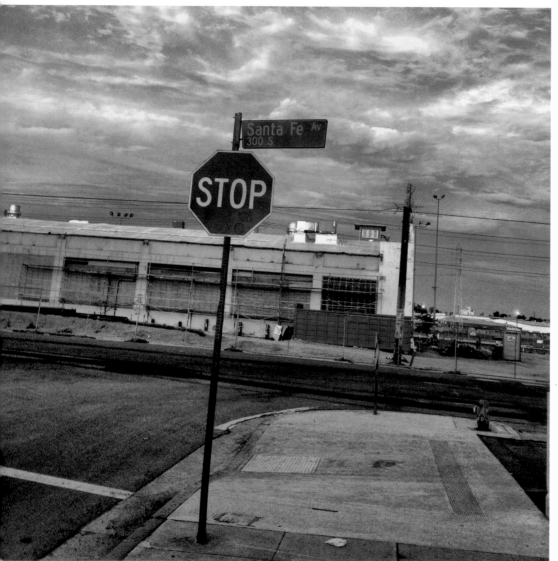

Peach skies near stop sign at
Santa Fe Avenue and 3rd Street

Alley along District Millworks

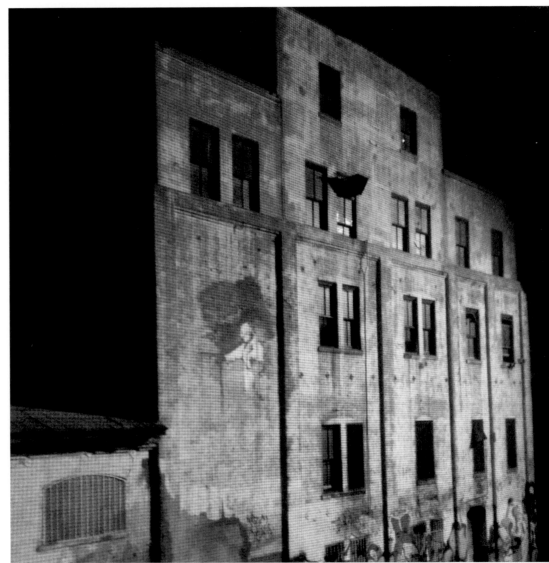

Urban giraffes along
Santa Fe Avenue

Arts District sign at 3rd Street
and Traction Avenue

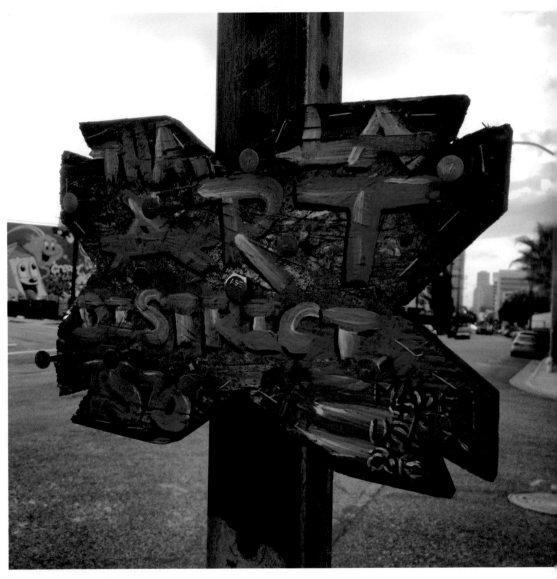

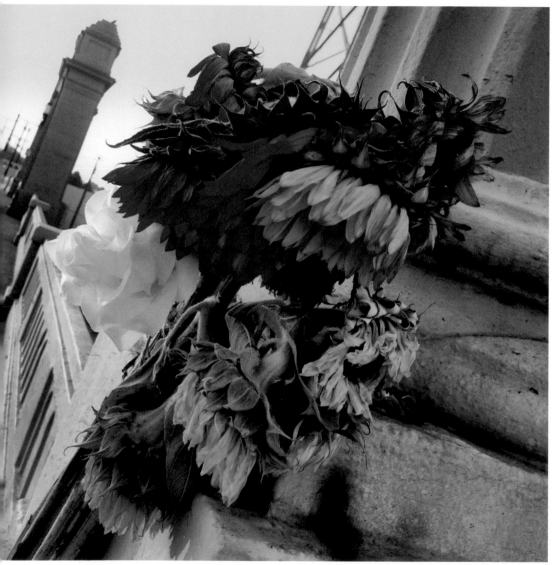

Flowers for Lance van Gils on
1st Street Bridge

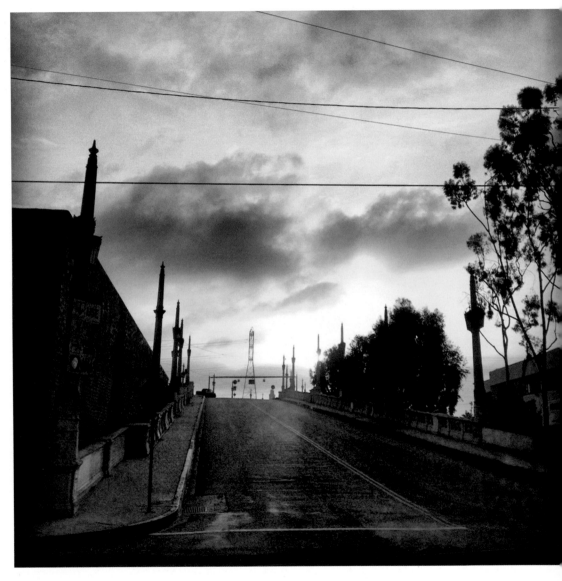

4th Street Bridge ramp at
sunrise on Mateo Street

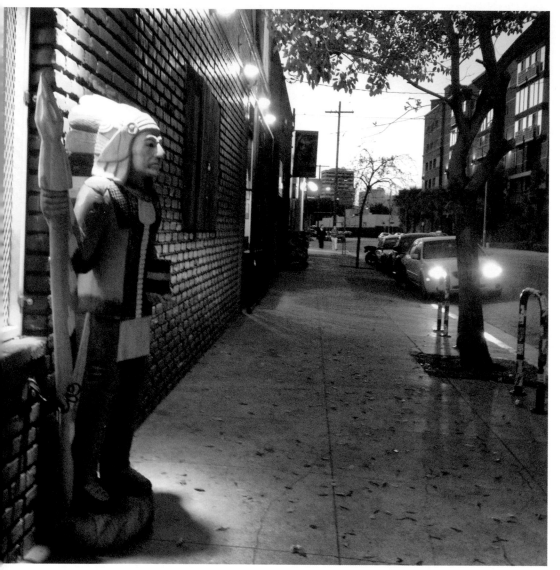

Bloom's wooden figure returns
for a brief period in 2012

Lebbeus Woods sculpture
at Traction Triangle

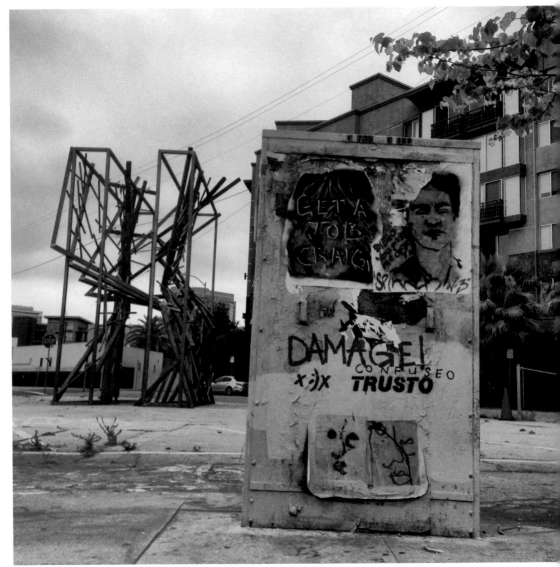

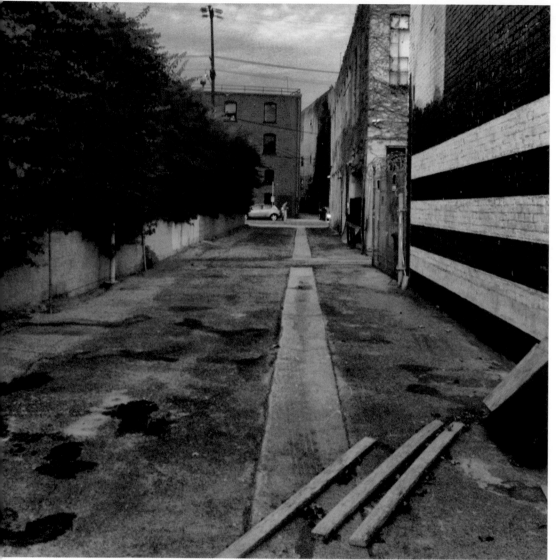

My favorite alley looking
backwards towards Vignes Street

Fuschia blooms on 3rd Street
near Eat.Drink.Americano

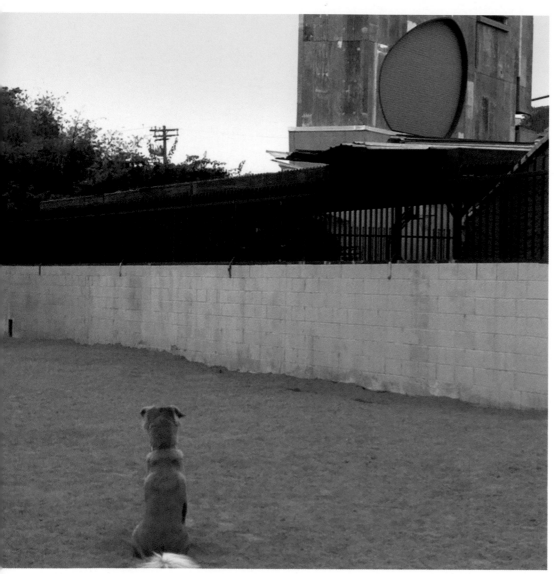

Buddy meditates in Arts District Dog Park by focusing on Tim Krehbiel's rooftop Ovoid Room

Looking up at stickered window
and serpentine wire on 3rd St.

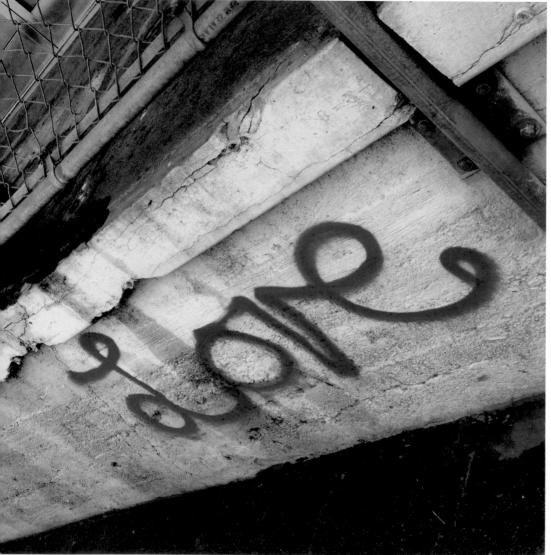

"Love" tag in my alley

Turquoise building and
blossoming jacaranda
on 7th Street

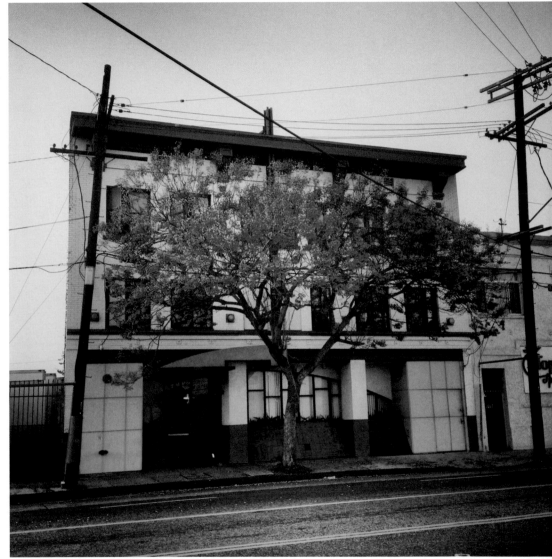

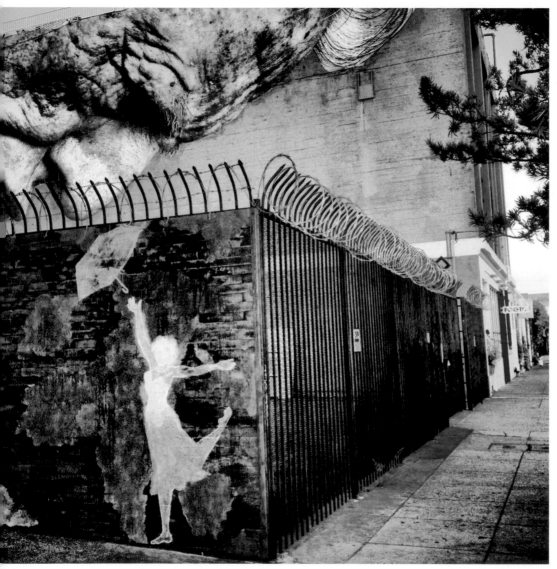

Dancing girl and JR wheatpaste

Exiting the garage
on a rainy morning

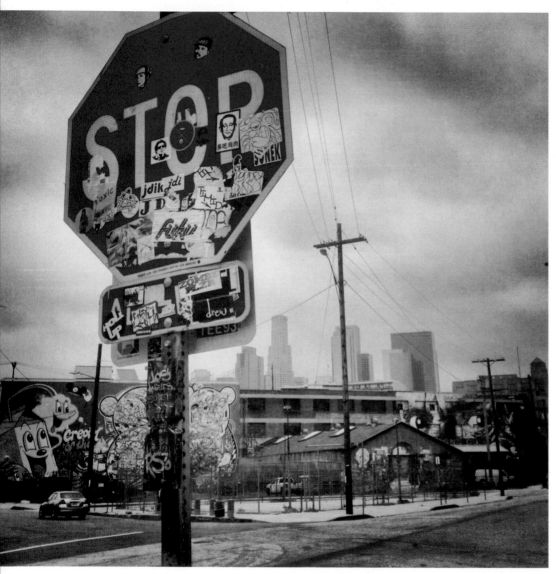

Foggy morning at 3rd Street and
Traction Avenue with view of
Downtown skyline

Yellow stairs on 940 E. 2nd Street building before condo conversion

"Sign of the cross" clouds
 in the sky

Turquoise fire hydrant and
graffiti on 2nd Street

Art installation in
Traction Triangle

New construction will cover these street murals by many now-famous artists

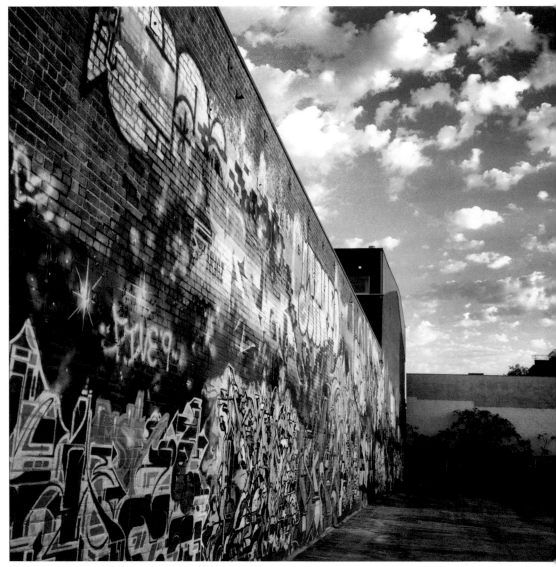

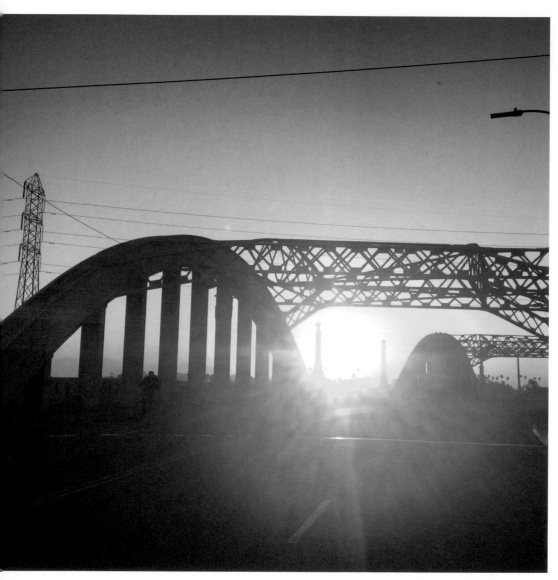

Sunrise over 6th Street Bridge

Lights along 923 E. 3rd
Street building

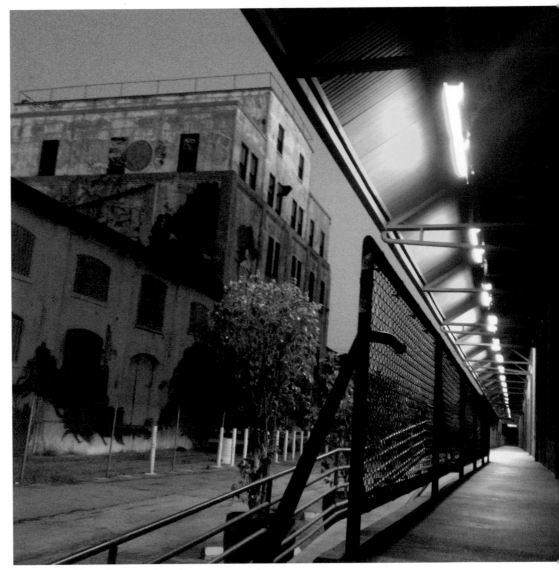

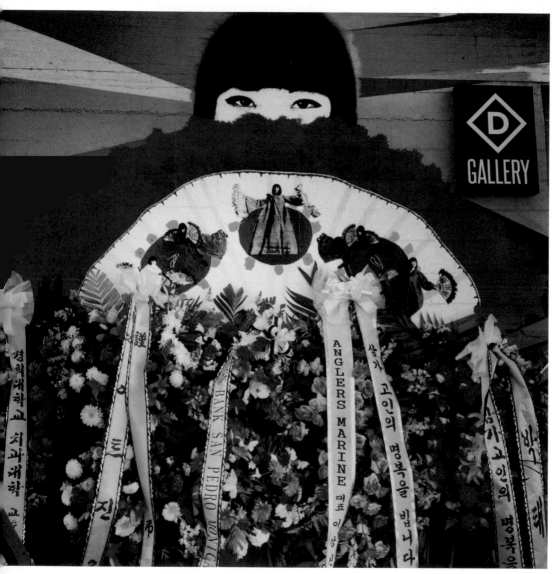

Floral memorials for Jason Ha's mom in front of Damon Martin's mural and District Gallery

Collateral damage ... fallen
blooms under tree on 3rd Street

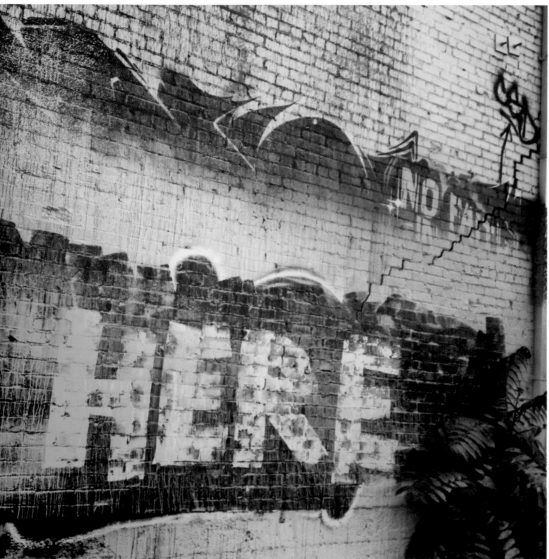

"HERE" detail of alley message

Shopping cart installation by
A.S. Ashley in Traction Triangle

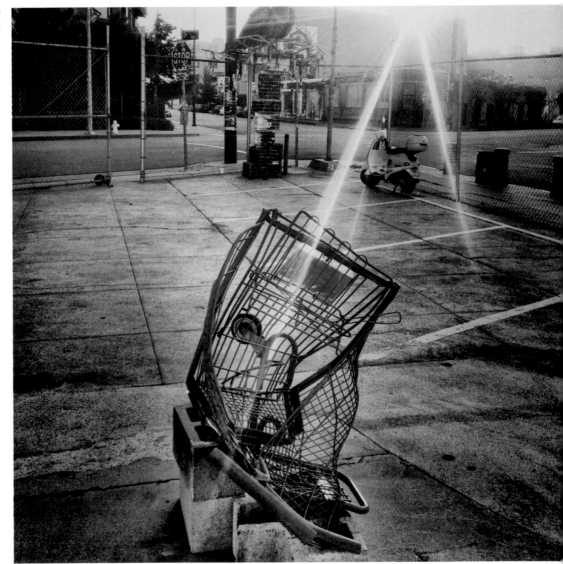

Citizens Warehouse (aka Pickle Works Building) sits empty after 1st Street Bridge expansion

Pink skies and skyline
from my rooftop

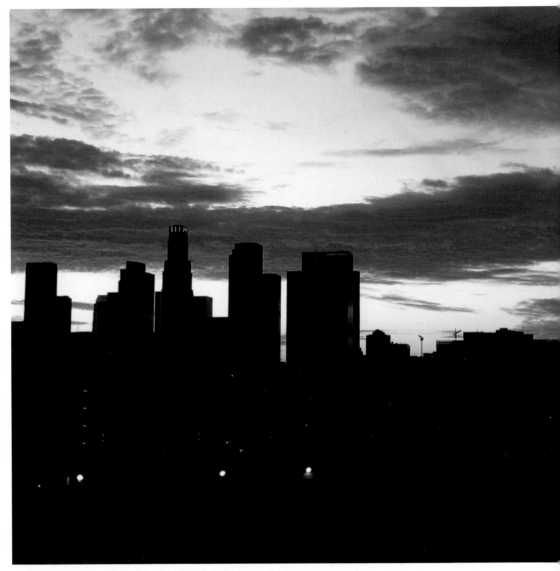

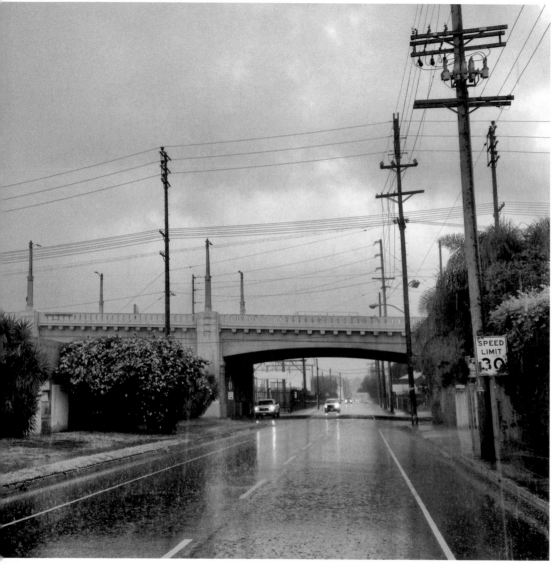

Rainy day on Santa Fe Avenue
near 6th Street Bridge

Graffiti alley off of Santa Fe
Avenue near Palmetto Street

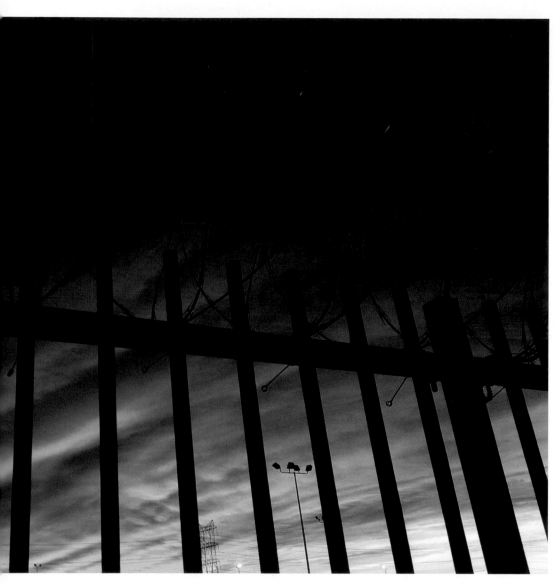

Sunrise on Santa Fe Avenue
with serpentine wire

Arts District Social Club on
Traction Avenue rooftop at sunset

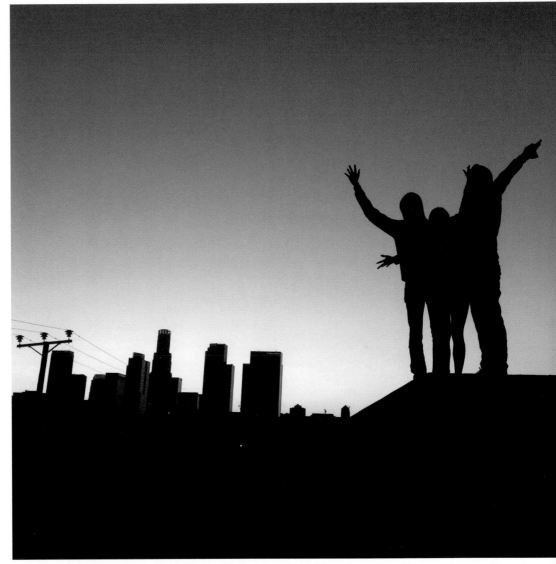

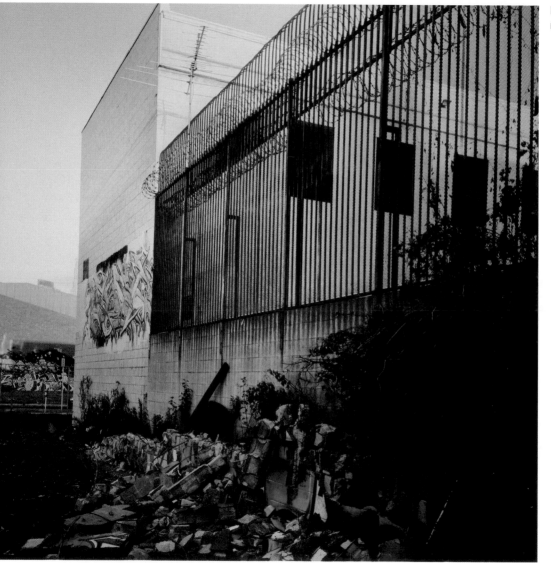

Rubble from demolition of murals on Megatoys

View of Kim West mural and
pigeon from my window

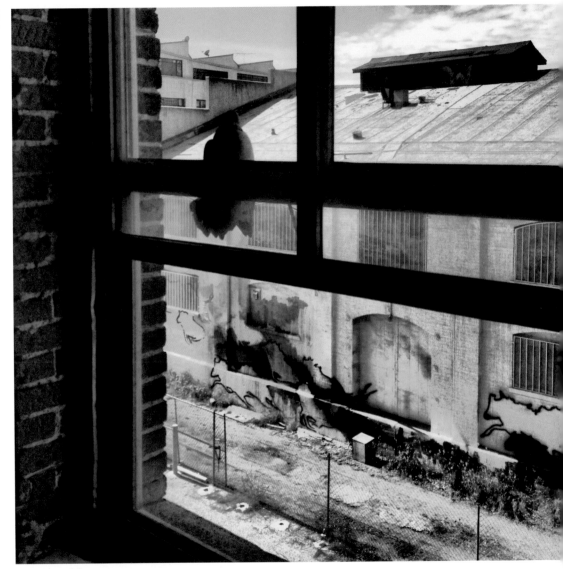

special thanks

Vatche and Foxy

Numerous people, things, and experiences ultimately led to this book: my dogs Vatche and Foxy who stop to sniff so often that I have to stand still and look around; my father H. Gary Richardson who raised our family in a machine shop and taught me that girls could do anything; my mother Patti Lou Richardson who proves anyone can start over at any age and is incredibly talented; and the rest of my beloved and rowdy clan.

Thanks also to those Los Angeles friends who are like family to me, including Cheech Marin (who reminds me that life can have a Side B that's even better than Side A), Natasha Marin, Bob Ujszaszi, Edgar Varela, Julie Rasmussen, Michael Ford (and his dog Quixote), Ted Meyer, Patricia Mitchell, Luis C. Garza, Connie Lopez and Sylvia Colorado, Dan Hodgdon and Lisa Gillespie, Scot Ezzell, Andrea Balter, Steve Rice, Andrew Jackson, and countless others who have been there for me over the years. Many thanks also to the OGs of the Arts District, my friends in the Arts District Social Club, all of the artists who have colored my world inside and out, and Daniel Lahoda whose work, through his community-endorsed L.A. Freewalls project, has resulted in numerous monumental murals that inspire me and others.

I want to specially highlight Christy Addis who, out of the blue, sent me draft designs of this book using web images from my blog. I was touched … I never thought anyone was actually moved by what I was sharing online. We've become fast friends, and I'm forever grateful that she reached out to me.

Last, I want to tip my hat to Joel Bloom, a man who cared deeply about the Arts District – the legacy of his work lives on throughout Downtown Los Angeles and beyond. He loved dogs, so I'm sure he would be pleased to share this honor with Vatche and Foxy!

bios

Melissa Richardson Banks
Photographer/Author

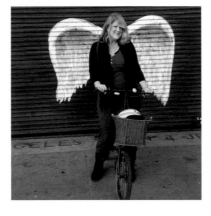

MELISSA RICHARDSON BANKS shies away from describing herself as a photographer, but she plays one most every day in the Arts District of Downtown Los Angeles. During her daily walks with her dogs Vatche and Foxy, she often takes unplanned photographs with an iPhone. A native of Texas, she's an adopted Angeleno who was drawn to the Arts District 20 years ago since its industrial feel and close-knit creative community reminded her of where she grew up in Flour Bluff. To earn a living and inspiring other parts of her life, she runs a marketing firm called CauseConnect, which helps businesses and nonprofits work well together to change the world. She also shares photos, stories, and information about the Arts District through her award-winning blog called Downtown Muse. Her artistic side is satisfied by managing the Chicano art collection of Cheech Marin, and taking snapshots.

Christy Addis
Art Director/Graphic Designer

CHRISTY ADDIS was leaving Los Angeles right about the time Melissa Richardson Banks was arriving. Nights of performing in the Arts District's much-loved but now-closed Al's Bar, and working in the set decorating departments of the film industry, were left behind to raise her kids in Virginia with her artist husband, Curtis Gutierrez. Eventually those kids grew up, and she has moved back to Los Angeles, this time with both an artist husband and an artist daughter, Isabel. She brought her degrees in graphic design and interior design together to establish her company, True Design, to develop products and provide design services reflecting her eye for color and balance, obsession with textiles, understanding of design history and appreciation of fine art. Her blog is True Design Report.